Brush Lettering
A · N · D
watercolour

This book now belongs to you!

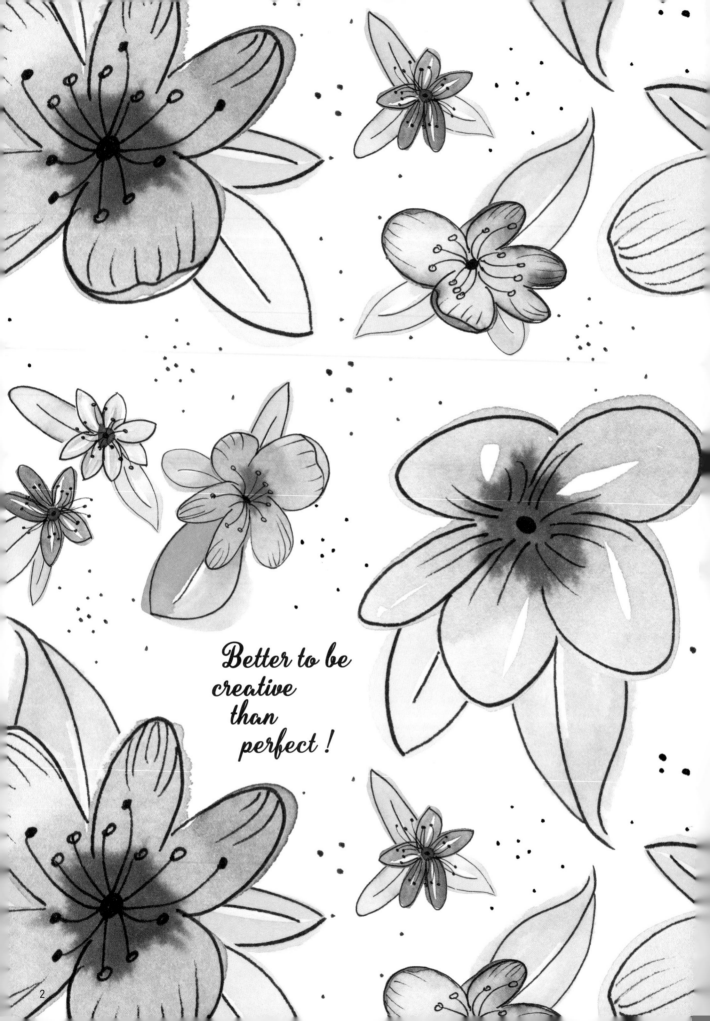

Better to be
creative
than
perfect !

List of contents

Anfang ist kein Meisterstück

GERMAN IDIOM

"Beginning does not constitute a masterpiece"

Preface

I am delighted that you are holding this book. This time, I am focusing in particular on the subjects of brush lettering and watercolours. For me, these are two wonderful topics, alongside modern calligraphy, that I simply adore and which go together extremely well, I find.

In all my projects, the main emphasis is on hand-crafted work. In the beginning, I thought that I had to make everything better and more beautiful ... but do you know what I discovered? This is not necessary at all. If I want perfect letters, I can type them on the computer. And for me, an important aspect of this book is that I want to encourage you to experiment with different fonts, colours and pens. Because, first and foremost, hand lettering should be fun - as an art form, without "right or wrong", and in line with the saying: just do it, it could turn out well!

In my case, I started with brush lettering and only gained experience with watercolours at a later stage. And then I understood for the first time how versatile they are. There are limitless options for experimenting with watercolours and they are THE perfect complement to brush lettering! I am not a natural watercolour artist, but I have grown to know and love the subject over the course of time and I am curious to know how you get on. I look forward to hearing about your personal experiences - as always you are welcome to post on **#happylettering**

Happy Lettering!

Katja

P.S.: AT THIS POINT, I WOULD LIKE TO EXPRESS MY SINCERE THANKS TO MARGIT WICKHOFF (WORT-SPIEL.AT), SANDRA JOCHER (SANDBLUME.AT), ROYAL TALENS (ROYAL-TALENS.COM) AND, OF COURSE TO MY FAMILY!

IN THIS BOOK, I ALSO USE MY DIGITAL HANDWRITING FONT, AMONGST OTHER SCRIPTS; THIS SAVED ME A LOT OF WORK WITH THE LAYOUT THIS TIME :)

Materials & equipment

BEFORE WE LAUNCH OURSELVES INTO THE FUN OF BRUSH LETTERING, I HAVE PUT TOGETHER A BRIEF OVERVIEW OF MATERIALS THAT I HAVE COME TO KNOW AND LOVE AND WHICH I USE FOR MY LETTERING PROJECTS. WHAT I AM PRESENTING TO YOU BRIEFLY HERE, IS MY OWN PERSONAL SELECTION OF BRUSHES, PENS, PAINTS AND TYPES OF PAPER.

BRUSH PENS

BRUSH PEN IS THE ENGLISH TERM AND REFERS TO A PEN WITH A BRUSH-LIKE TIP.

There are different kinds of brush pens. The main difference lies in the size and type of the brush tip. These can be made either of individual bristles or of nylon, or it may be a felt tip. Regardless of the materials they are made of, all brush pens are flexible and respond when you apply pressure so that you can create strokes of different widths.

For beginners, I personally recommend brush pens with nylon or felt tips, since these are easier to handle. Brush pens with tips made of individual bristles are much more difficult to control. In the end, however, it depends entirely on your own personal preference which brush you choose to write or draw with. The best thing to do is to try out different brush pens in order to find your personal favourite.

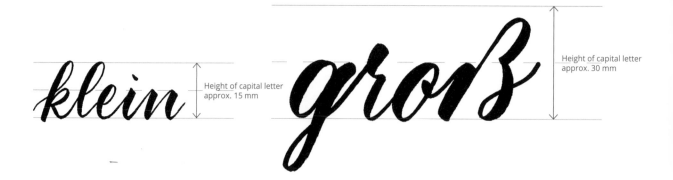

Height of capital letter approx. 15 mm

Height of capital letter approx. 30 mm

BRUSHES

Conventional round brushes made of natural or synthetic bristles can also be used for brush lettering.

Brush Pens

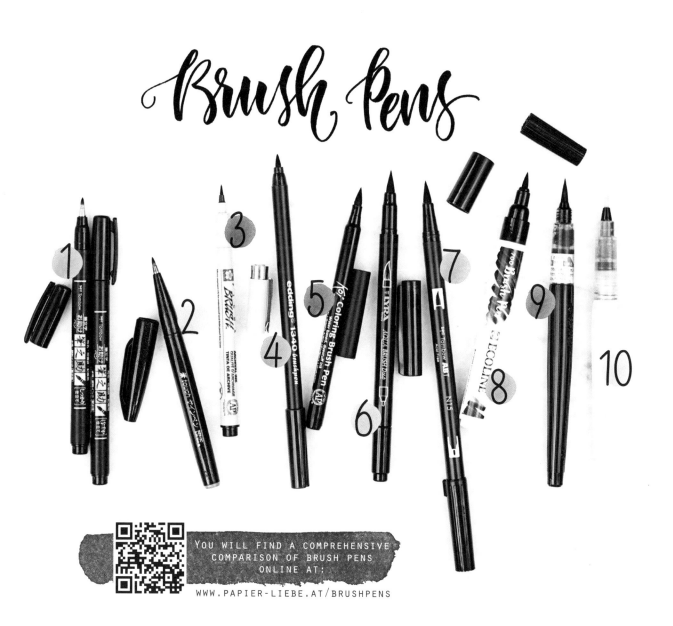

You will find a comprehensive comparison of brush pens online at:

www.papier-liebe.at/brushpens

PAPER FOR BRUSH PENS

My initial ignorance ruined a lot of felt tip pens in a very short period of time :(

The right choice of paper is particularly important for brush pens with felt tips! I recommend that you only use brush pens on paper with an extremely smooth, even surface. Do a test by stroking a sheet of paper with the palm of your hand. If it feels smooth and even, you can assume that the paper is also suitable for your pens. I particularly recommend the following brands of paper for brush pens with felt tips:

Canson sketchbook XL Marker 70gsm
Rhodia notebook BLANK OR WITH A DOT GRID, 80gsm
Tracing paper 80gsm
Clairfontaine DCP copy paper 100gsm
Hahnemühle Hand Lettering paper 170gsm
Royal Talens ECOLINE Liquid watercolour print paper 190gsm

WRITE A WORD WITH A PENCIL OR FINELINER.

REINFORCE ALL THE DOWNSTROKES WITH A SECOND LINE.

YOU CAN LEAVE THE SPACES YOU HAVE CREATED BLANK OR FILL THEM IN — EITHER COMPLETELY OR WITH A PATTERN.

However, if you would like to write on paper that is less smooth, I recommend you choose brush pens with nylon tips, since these are less sensitive. Or, alternatively, you can use a fineliner and create your lettering using **Faux Calligraphy**.

Tracing paper is my top insider tip! The transparency of the paper makes it easier for you to practise and to make corrections repeatedly at the drafting stage. It could perhaps even save you buying a light pad.* When you are practising, lay a sheet of tracing paper over the desired practice template and copy the individual letters. This allows you to practise over and over again.

*LED light box/table

einfach mal machen – könnte ja gut werden

"Just do it, it could turn out well."

Brushes for watercolour

For lettering and watercolour projects you primarily need a
round brush. A **flat brush** and a **blending brush** complete
the basic equipment necessary to make a successful start.

1) Round brush
THE BRISTLES GRADUALLY
TAPER INTO A POINT.

2) Flat brush
THE BRISTLES ARE
PRESSED FLAT INTO
A FINE, WIDE TIP.

3) Mop brush
THIS BRUSH HAS LOTS
OF BRISTLES AND CAN
THEREFORE PICK UP
A LOT OF WATER.

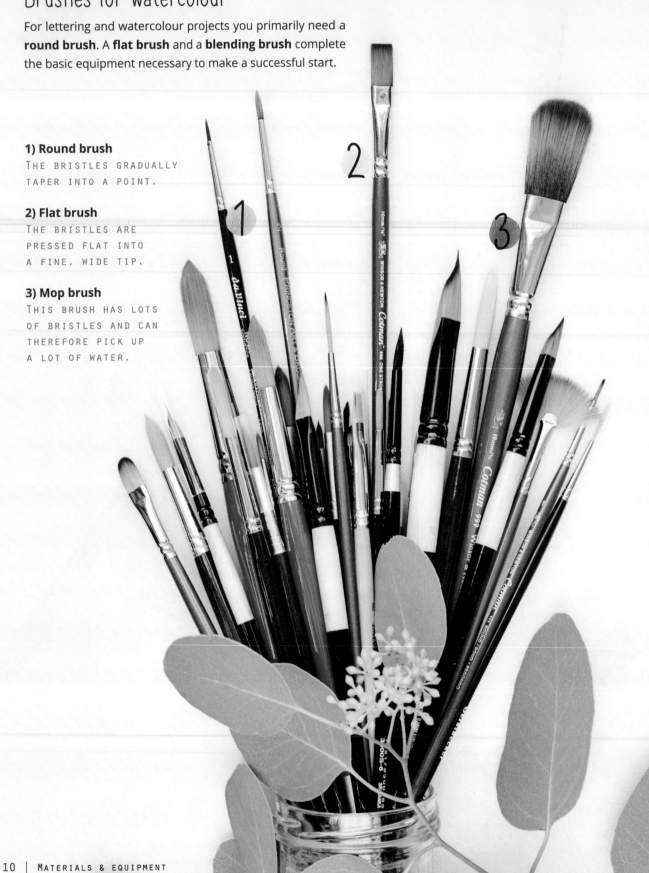

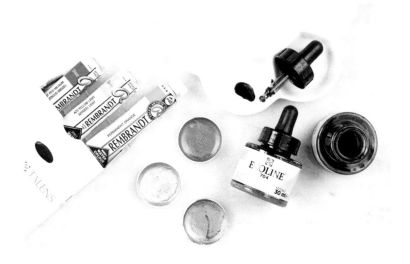

WATERCOLOUR PAINTS

THESE PAINTS ARE NOT OPAQUE. THEY ALLOW ANY PREVIOUSLY APPLIED COLOUR OR THE PAPER TO SHINE THROUGH. THE PAINTS ARE DILUTED WITH WATER SO THAT THEY CAN BE APPIED TO THE PAPER.

Tube, palette or liquid paint?

All three give the same result, but they need to be handled differently.

Tube

These paints have a creamy consistency and you need to first mix them with water. To do this, you take a colour mixing palette or some other small mixing dish (e.g. a saucer) and place a dab of paint on it. Then add some water and mix the paint until it has a smooth consistency. If necessary, you can always add more water or paint.

Palettes or paint box

The paints in palettes are completely dry and in a solid state, but they can easily be dissolved by adding water. In this case too, you can pick up some paint with your brush, transfer it to a mixing dish and further dilute it with water in order to get a lighter, more transparent colour, or you can even mix colours together if needed.

Liquid paint

As the name implies, this paint is liquid and already mixed with water. You can therefore pick up the ready-made paint directly with your brush and start to paint or draw with it. You can also take the paint out of the container and dilute it further with water or mix it with other colours.

THE NEW LIQUID PAINTS FROM ECOLINE NOW COME WITH A PRACTICAL PIPETTE. I HAD THE PLEASURE OF TESTING THE PAINTS FOR YOU BEFOREHAND. YOU WILL FIND AN OVERVIEW OF THIS PRODUCT RANGE ONLINE AT: WWW.PAPIER-LIEBE.AT/ECOLINE

Whether you choose palettes, tubes or liquid watercolour paints is entirely up to you. You can even simply use an ordinary school paint box for your watercolour projects, as I did in the beginning too. In the meantime, however, the paints that I like to work with include the following:

ECOLINE liquid watercolour paints WHICH HAVE BEAUTIFUL LUMINOSITY

SAKURA Koi Watercolours POCKET FIELD SKETCH BOX

Schmincke Akademie Aquarell WATERCOLOUR PAINTBOX

Prima Marketing Watercolour Confections & Metallic Accents

KURETAKE Gansai Tambi WATERCOLOUR PAINTS INCLUDING METALLIC PAINTS

Finetec METALLIC PAINTS

You also need

Jars of water AT LEAST 2

Mixing dishes MADE OF PLASTIC OR PORCELAIN

Watercolour paper A BLOCK OR SEPARATE SHEETS

Absorbent paper E.G. KITCHEN ROLL OR PAPER TOWELS

Washi tape or painter's masking tape

An underlay for drawing MADE OF PLYWOOD OR CHIPBOARD, IF NECESSARY

And a good cup of coffee OPTIONAL ;)

For special effects

The great thing about watercolour is that there are many techniques and resources that you can use and combine as necessary, so that you constantly come up with new ideas and designs. I also use the following resources for various special effects:

WINSOR & NEWTON Iridescent Medium – FOR AN EXTRA GLITTERY EFFECT :) CAN BE EASILY MIXED WITH WATERCOLOUR PAINTS TO ADD A TOUCH OF GLAMOUR.

WINSOR & NEWTON Art Masking Fluid

MOLOTOW GRAFX™ Art Masking Liquid MASKING PEN
– BOTH OF THESE PROTECT THE SELECTED AREAS OF PAPER FROM PAINT. THE PAPER BECOMES WATER-RESISTANT IN THE AREAS WHERE THE MASKING FLUID IS APPLIED AND THUS PREVENTS THE WATERCOLOUR PAINT BEING ABSORBED. ONCE DRY, THE MASKING FLUID MUST BE REMOVED – EITHER WITH AN ERASER OR BY SIMPLY RUBBING IT OFF WITH YOUR FINGER.

White wax crayons WATERCOLOUR PAINTS DO NOT STICK TO WAX CRAYON. YOU CAN THEREFORE CREATE ATTRACTIVE WHITE SPACES WHEN YOU PAINT OVER AREAS WHERE YOU HAVE APPLIED WAX CRAYON.

TIP:

YOU NEED WATER TO DILUTE THE PAINTS AND ALSO TO DAMPEN THE PAPER. YOU SHOULD PREFERABLY HAVE TWO JARS OF WATER — ONE WITH CLEAN WATER AND ONE TO CLEAN YOUR BRUSHES.

Paper for brushes and watercolour paints

For practice, you can write/paint/draw with watercolour paints and brushes on any type of paper without any restrictions. For anything beyond this, I would recommend you use watercolour paper, such as:

Strathmore Watercolour paper 190GSM
Royal Talens ECOLINE Liquid watercolour print paper 190GSM
Royal Talens ECOLINE Liquid watercolour paper 290GSM
Fabriano acquarello watercolour ARTISTICO EXTRA WHITE, 300GSM
Boesner watercolour ROUGH, 300GSM
Gerstaeker watercolour JUBILEE BLOCK 425GSM

There are various criteria for watercolour paper. Above all, the density/grammage of the paper (GSM) is important. Thinner paper is more likely to warp if you are working with a lot of water. However, there is a little trick you can use to combat this: attach all the sides of the paper to the surface below, e.g. with masking or washi tape. Or you can use ready-made pads that are glued on all four sides.

Depending on the paper production process, watercolour paper has different surface textures ranging from satin finish to matt finish, fine grain to coarse grain, right up to rough finish. A distinction is made between "cold pressed" and "hot pressed" paper.

Cold pressed
During the production process, this paper is pressed through rollers without heat. Depending on the pressing mat used, different surfaces are produced: fine grained, coarse grained, rough or torchon (linen structure with a pronounced, cloud-like surface). The irregular surface of cold pressed paper makes the colours on the paper appear to have more texture and it is particularly suitable for wet-on-wet techniques and washes.

Hot pressed
Satin and matt papers are pressed between hot rollers during the production process and therefore have a smooth surface. This paper is ideal for delicate work but also for glazing. Paints take on a brilliant appearance on this paper.

TIP:

THE NEW LIQUID WATER COLOUR PAPER FROM ROYAL TALENS WAS SPECIALLY DEVELOPED FOR THE LIQUID WATERCOLOUR PAINTS AND BRUSH PENS FROM ECOLINE AND GIVES EXCELLENT EXPRESSION TO THE BRILLIANT COLOURS.

ECOLINE PRINT PAPER IS ALSO IDEAL FOR PRINTING, ALLOWING YOU TO FIRST OF ALL DESIGN, SCAN AND THEN PRINT OUT YOUR TEMPLATES AND WRITE OR PAINT ON THEM WITH THE PENS OR LIQUID PAINTS. THIS ALLOWS YOU TO REPRODUCE LETTERING TEXTS / PROJECTS AND TO THEN GIVE THEM AN INDIVIDUAL CHARACTER.

WASHES

COLOUR WASHES WITH WATER — PERFECT FOR CREATING COLOUR TRANSITIONS — SEE PAGE 49

GLAZING

APPLYING COLOURS IN LAYERS - SEE PAGE 49

In order to plan, sketch and also realise your projects successfully, you need some other equipment. I am fairly certain, however, that you already have most of these things at home.

PENCILS

It is best to use a pencil to make your first sketches and rough drafts. You can use any of your favourite pencils for this, provided that you are not working on final artwork paper. If you intend to draw over your pencil sketch with a fineliner or brush pen, however, I recommend that you use a soft or very soft pencil (grade B or HB). When you are doing a rough draft you should not press too hard, however, and try to use a blunt tip, so that the lines do not penetrate the paper surface too much and can be erased more easily. However, be careful when you are using watercolour paints: these are glazing (translucent), meaning that the pencil lines cannot be erased where the paint is applied over them and will remain visible. This can perhaps create an attractive effect, but it is not usually what is wanted.

Personally, my favourite pencils are:

FABER-CASTELL TK 9400 CLUTCH PENCIL GRADE 4B
FABER-CASTELL Grip 2001 GRADE B

ERASERS

For a good pencil you also need a good eraser. Not only can a bad eraser smudge your work, but it may also damage the paper. Over the years, I have found my favourite and now I swear by kneadable erasers, like this one, for example:

Boesner kneadable eraser GREY & WHITE
IT CAN BE DIVIDED UP AS YOU WISH AND KNEADED INTO THE REQUIRED SHAPE; THE BEST THING IS THAT IT DOES NOT LEAVE ANY ANNOYING CRUMBS!

I also occasionally use these erasers:

STAEDTLER Mars plastic WHITE & FIRM
Tombow MONO zero 2.3 ERASER IN PEN FORM FOR PRECISION ERASING

RULER

A ruler is indispensable in order to keep everything perfectly aligned on the paper, whether in straight lines or perhaps also at angles. I like to use a conventional set-square, which can also give me specific angles and is, most importantly, transparent. This can be very useful in planning and organising your work.

FINELINERS & GEL ROLLERS

Fineliners work very well for brush lettering and with watercolours, either for reinforcing contours or for drawing monoline lettering and faux calligraphy (SEE PAGE 8).
My favourites are:

PIGMA MICRON IN SIZES 005/01/02/03/05

I especially like to use gel rollers for adding highlights to lettering.

Uni-ball Signo broad PIGMENT INK WHITE OR GOLD
SAKURA GELLY ROLL WHITE OR METALLIC COLOURS

There are, of course, a lot of other gel rollers and fineliners available, but be careful to ensure that they are fade resistant and above all waterproof; otherwise you can expect some nasty surprises. It is very simple to test whether your pens (and brush pens) are waterproof, using a brush stroke and clean water:

THIS IS USED TO REFER TO SIMPLE WRITING WHERE THERE IS NO DIFFERENTIATION BETWEEN THIN UPSTROKES AND THICK DOWNSTROKES. THE LINE THICKNESS CAN VARY ACCORDING TO THE PEN USED.

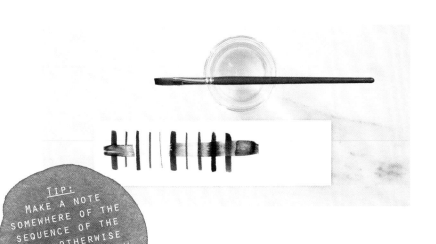

TIP:
MAKE A NOTE SOMEWHERE OF THE SEQUENCE OF THE PENS, OTHERWISE YOU WILL NOT KNOW AFTERWARDS WHICH PEN MADE WHICH LINE ;)

I WOULD LIKE TO SAY ONCE AGAIN AT THIS POINT THAT IT DEPENDS ENTIRELY ON YOUR PERSONAL PREFERENCES AND ON YOUR FINANCIAL RESOURCES WHICH PENS, BRUSHES AND TYPES OF PAPER YOU CHOOSE TO WORK WITH; TRUE TO THE MOTTO: ANYTHING IS POSSIBLE, NOTHING IS OBLIGATORY!

Brush Lettering

You have probably read about the structure of letters and the rules of font design on various occasions, or you have at least heard about these topics. Here, I will explain just a few of the most important terms. The good thing about hand lettering is that you do not have to adhere strictly to these rules – after all, the main aim is to find your own style. ;)

"Learn the rules so that you can break them more easily"

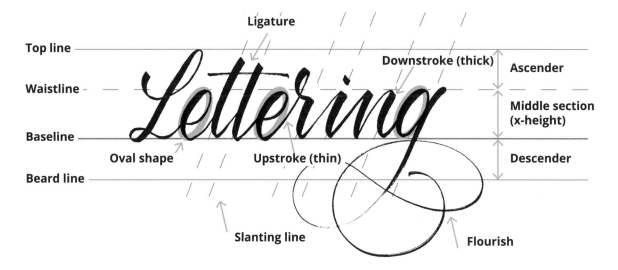

Ligature / **Top line** / **Downstroke (thick)** / **Ascender** / **Waistline** / **Middle section (x-height)** / **Baseline** / **Oval shape** / **Upstroke (thin)** / **Descender** / **Beard line** / **Slanting line** / **Flourish**

UPWARD STROKE
WITH LIGHT PRESSURE

To achieve the most harmonious appearance possible in your writing, I recommend that you align all your letters on the baseline and to the x-height, ascender and descender. The angle of inclination of your letters should also be the same as far as possible. You should always create your letters using oval shapes too, which produces a more elegant style of writing.

DOWNWARD STROKE
WITH HEAVY PRESSURE

The key to success lies in applying varying amounts of pressure to the brush or brush pen - i.e. thin upstrokes and thick downstrokes. This sounds very easy, but it takes some practice. The best thing to do is to start with the practice exercises for basic strokes on the next page.

These basic strokes are the foundations of our letters that are composed of two or more shapes. In brush lettering, we talk about drawing the letters rather than writing them. That is precisely why it is completely irrelevant whether you have beautiful handwriting or not. Once you have internalised the basic strokes, you can use them to construct more or less all the letters in any script.

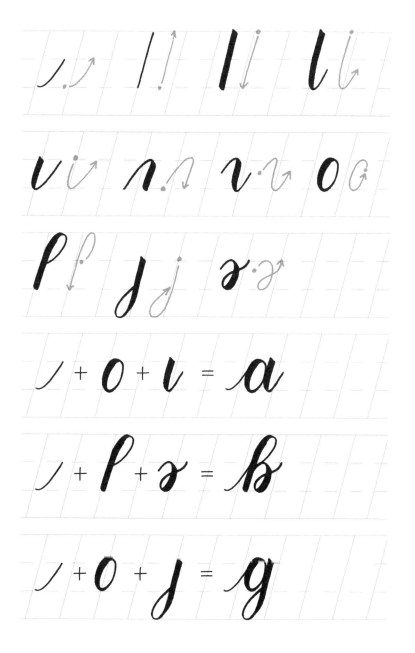

BASIC STROKES

Start with the line at the respective dot and be careful to make thin, upward strokes and thick downward strokes.

You can also use these basic strokes as a good warm up exercise.

… and this is an example of how you construct your letters from them.

You can download and print out a template for practising your basic strokes as well as practice grids at www.papier-liebe.at/vorlagen

CURSIVE SCRIPT – WITH A SMALL BRUSH PEN

abcdefghij
klmnopqrs
tuvwxyz

ABCDEFGH
IJKLMNOP
QRSTUVW
XYZ

REFERENCE SHEET FOR THE STRUCTURE OF LETTERS

I WILL SHOW YOU THE STRUCTURE OF THE INDIVIDUAL LETTERS USING THIS ALPHABET. IN EACH CASE, START AT THE POSITION OF THE DOT AND COMPLETE THE LETTERS USING THE ARROWS IN THE CORRECT SEQUENCE. THIS WILL ALSO PRODUCE THE THICK DOWNSTROKES AND THIN UPSTROKES. IF YOU FOLLOW THIS APPROACH, YOU WILL ALSO BE ABLE TO CONSTRUCT ALL OTHER STYLES OF WRITING (SEE THE FOLLOWING PAGES).

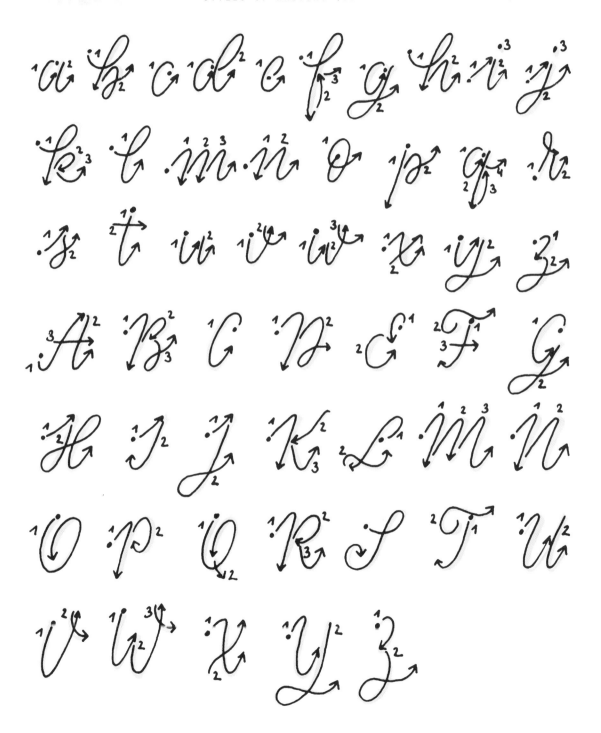

THE ASCENDERS AND THE DESCENDERS OF THE LETTERS MAY VARY, OF COURSE. THE IMPORTANT THING IS TO AVOID COMBINING TOO MANY DIFFERENT STYLES IN ONE PIECE OF LETTERING; OTHERWISE YOUR WRITING WILL LOOK AGITATED.

EXAMPLE:
COMPARE THE
ASCENDERS HERE

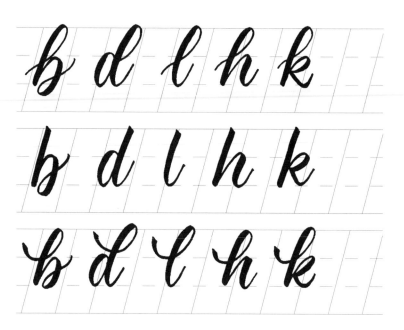

EXAMPLE:
COMPARE THE
DESCENDERS HERE

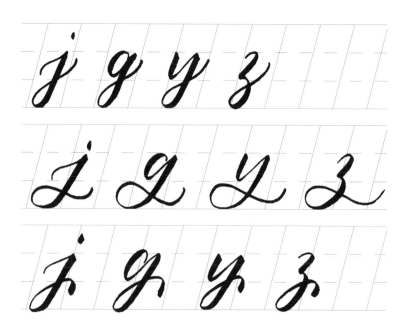

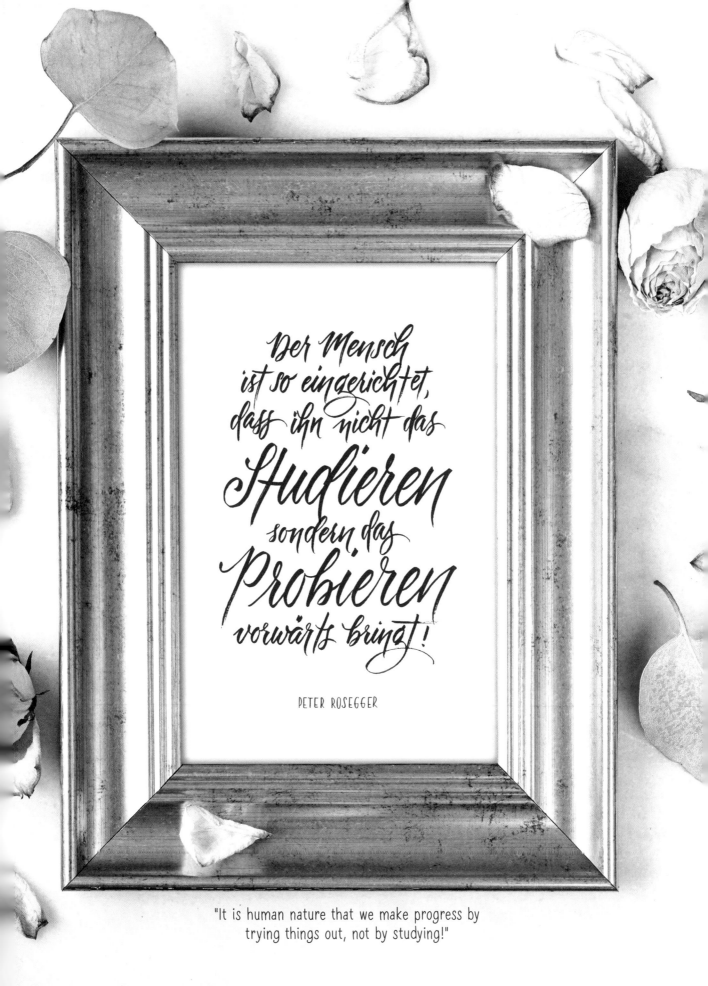

Der Mensch
ist so eingerichtet,
dass ihn nicht das
Studieren
sondern das
Probieren
vorwärts bringt!

PETER ROSEGGER

"It is human nature that we make progress by
trying things out, not by studying!"

CURSIVE SCRIPT — WITH A LARGE BRUSH PEN

PEN: EDDING® 1340
BRUSH PEN

Illustration 100% of original size

abcdefg

hijklmn

opqrst

uvwxyz

A B C D E
F G H I J K
L M N O P
Q R S T U
V W X Y Z

CURSIVE SCRIPT – WITH A WATER BRUSH

Pen: SAKURA Koi
SMALL WATER BRUSH

Illustration 100% of original size

a b c d e f g

h i j k l m n

o p q r s t

u v w x y z

THE WATER BRUSH IS A VERY VERSATILE WRITING TOOL. USING THIS
BRUSH WITH ITS INTEGRATED WATER RESERVOIR, YOU CAN EASILY MIX
UP PAINT FROM A SMALL POT, TAKE PAINT DIRECTLY FROM A LIQUID
PAINT CONTAINER OR EVEN FILL IT UP WITH INK.

NOTE: THE SLIGHTLY ANGULAR OUTLINES OF THESE LETTERS WERE
CREATED BECAUSE I USED ROUGH PAPER.

Sei du selbst,
denn alle
anderen gibt
es schon.

"Be yourself, for everyone
else is already taken."

A B C D E F G
H I J K L M N
O P Q R S T
U V W X Y Z

CURSIVE SCRIPT — ROUGH

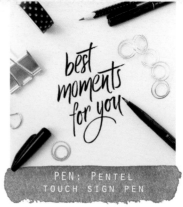

a b c d e f g h i

j k l m n o p q r

s t u v w x y z

Rough Script
LETTERING

THIS SCRIPT IS EYECATCHING DUE TO ITS DYNAMIC, SWEEPING DOWNWARD STROKES AND PRONOUNCED DESCENDERS. TRY TO CONSCIOUSLY EXECUTE THE DOWNSTROKES IN A RAPID DOWNWARD MOVEMENT SO THAT YOU CREATE A "FRAYED" APPEARANCE TO THE LINE. I LOVE THIS STYLE AS YOU CAN PROBABLY SEE FROM A FEW OF MY PIECES OF WORK. ;)

ABCDEFG
HIJKLM
NOPQRST
UVWXYZ

PRINT SCRIPT – BOLD

PEN: DA VINCI NOVA
SYNTHETICS BRUSH 1

Illustration 100% of original size

abcdefg

hijklmn

opqrst

uvwxyz

You can create these letters with a conventional brush or brush with a water reservoir. Try to concentrate on making thick downward strokes and thin upward strokes when you are drawing the letters.

ABCDEFG
HIJKLM
NOPQRST
UVWXYZ

It takes practice to write with a brush. Carry out the movements as slowly as possible to give the brush bristles time to change direction.

Make your own happiness.

PRINT SCRIPT – SANS SERIF

PEN: TOMBOW
FUDENOSUKE HARD TIP

Illustration 100% of original size

abcdefghijklmn
opqrstuvwxyz

ABCDEFGHIJKLMN
OPQRSTUVWXYZ

TIP:

PRINT LETTERS CAN
BE WONDERFULLY
COMBINED WITH
CURSIVE SCRIPT.
JUST TRY OUT
SOME DIFFERENT
ALTERNATIVES.

You can generally produce print letters in sans serif font with any writing tool. If you are using a brush pen, be careful to make thin upstrokes and thick downstrokes as you draw. This makes your alphabet much more exciting. Tall, slim letters also look very modern. They can also be combined very successfully with a cursive script.

PRINT SCRIPT – WITH SERIFS

Serifs are the little 'feet' attached to the ends of letters. They may be pronounced to a greater or lesser extent. I personally use very simple serifs in the form of small 'crossbars' – as you can see in the following example.

abcdefghijklmn
opqrstuvwxyz

ABCDEFGHI
JKLMNOPQR
STUVWXYZ

PRINT SCRIPT – DRY BRUSH

Illustration 100% of original size

a b c d e f g

h i j k l m n

o p q r s t

u v w x y z

ABCDEFG
HIJKLM
NOPQRST
UVWXYZ

As the name suggests, dry brush lettering is a style of writing carried out with a very dry brush or brush pen. Try to draw sweeping lines to create the rough textured effect. You can achieve this very successfully with a Pentel brush pen, preferably using very little ink.

Alternatively, you can use old, worn-out brush pens such as the Tombow fudenosuke or the Pentel touch sign pen. If the pen has no colour left in it at all, here is a little tip: just dip the nylon tip in ink and you will be able to write with it again for a short period of time. :)

BLOCK CAPITALS

PEN: FLAT BRUSH
W&N COTMAN 10

Illustration 70% of original size

A B C D E
F G H I J K
L M N O P
Q R S T U
V W X Y Z

You draw these block capitals, which are made up of simple straight lines and round shapes, with a flat brush. Admittedly, it is not very easy to construct these shapes – the important thing is that you do not put your hand down to make it easier to draw the curves. If necessary, you can also rotate the paper so that you can draw parts of the letters more easily. If you are right-handed, it is easier to move the brush from left to right than the reverse, because otherwise it goes against the brush stroke. To me, the less-than-perfect lines and curves are simply a part of hand lettering.

With block lettering it is easy to highlight words and also to combine them with words in cursive script, for example.

be you

Pimp your Style

Now that I have shown you various alphabets created with different writing tools, I would like to give you an overview and a few ideas of how you can improve, vary and enhance your letters and words. Believe me, this is where the fun really starts. :) I have chosen the words "love" and "love letter" to give you a direct and simplified comparison of the various possibilities that exist.

TALL vs. WIDE LOVE LOVE

SPACING LOVE

ANGLE LOVE

VARIABLE X-HEIGHTS
Compare the middle bar on the „e" LOVE LOVE LOVE

WITH vs. WITHOUT SERIFS LOVE LOVE

THICK vs. THIN LOVE LOVE

MIX OF UPPER & LOWER CASE LETTERS	Love Letter
MIX OF CURSIVE & PRINT SCRIPTS	
LIGATURES Connections between two or more characters	
FLOURISHES	Love See page 38
BOUNCE LETTERING „HOPPING" LETTERS	love letter THE LETTERS ARE NOT ALL ALIGNED ON THE BASELINE
DECORATIVE FEATURES	LOVE
SHADOW vs. **3D**	LOVE LOVE
ALIGNING TEXT ALONG A PATH	

Flourishes

I JUST LOVE FLOURISHES AND I KNOW FROM EXPERIENCE THAT IT IS NOT VERY EASY IN THE BEGINNING TO COMBINE THESE PRETTY "LINES" WITH YOUR LETTERING. WHERE DO I PLACE THE FLOURISHES? WHICH SHAPE SHOULD I CHOOSE? AND HOW DO I EVEN CONSTRUCT THEM? I HOPE THAT I CAN GIVE YOU ONE OR TWO TIPS ON THIS SUBJECT TO HELP YOU EMBELLISH YOUR LETTERING TO MAXIMUM EFFECT IN THE FUTURE.

TIP NO. 1

INCREASE YOUR MUSCLE MEMORY BY PRACTISING THE BASIC FORM OF FLOURISHES OVER AND OVER AGAIN

TIP NO. 2

USE A PENCIL AND TRACING PAPER TO PRACTISE

TIP NO. 3

DO NOT APPLY PRESSURE TO YOUR BRUSH PEN

One of the most important rules of brush lettering is this: apply pressure when executing downward strokes. There is an exception, however, and that is when you draw flourishes. In this case the most beautiful results are achieved if you draw them with a flowing hand movement. This means that you should know in advance the direction your strokes will take and also, that you should only use the tip of your brush pen to draw them. To avoid having to think about this too much when you are lettering, I recommend that you practise the basic forms of flourishes over and over again.

The best thing to do is to practise with a pencil; then you do not need to concentrate on the tip of your brush pen. To start with, take a piece of tracing paper and trace the shapes repeatedly until your muscles have saved the sequence of movements and you can draw them without using a template.

STEP 1
START WITH A WAVY LINE

STEP 2
EXTEND THE FIRST WAVY LINE WITH A SECOND WAVY LINE IN THE OPPOSITE DIRECTION

STEP 3
ADD A FINAL SPIRAL TO COMPLETE YOUR FLOURISH

Once you have mastered the basic shape of the flourish, you can venture on to other alternatives, so that you can combine them with your lettering at a later stage - regardless of whether they are ascenders, descenders or horizontal lines or whether th ey occur at the start or end of a word. There are countless possibilities (see the examples below).

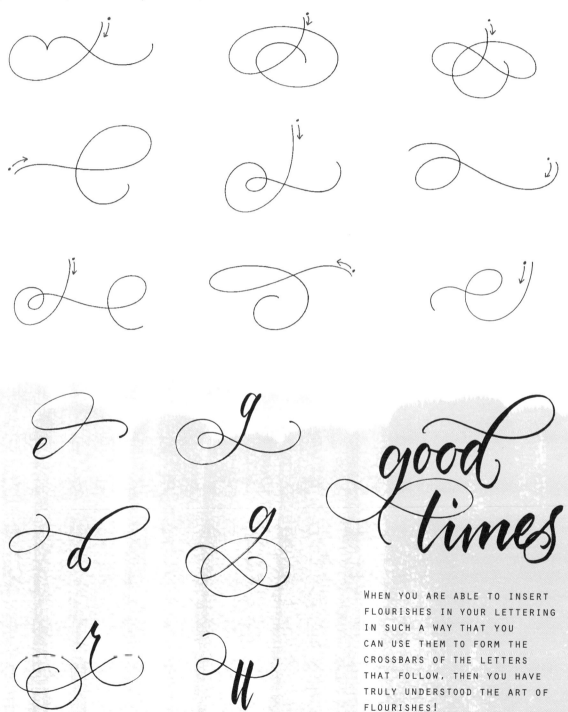

WHEN YOU ARE ABLE TO INSERT FLOURISHES IN YOUR LETTERING IN SUCH A WAY THAT YOU CAN USE THEM TO FORM THE CROSSBARS OF THE LETTERS THAT FOLLOW, THEN YOU HAVE TRULY UNDERSTOOD THE ART OF FLOURISHES!

Shadow & Light

You can enhance your brush lettering very easily with some simple tricks. I will show you an alternative here using a concrete example. Shadow and light reflections can really spice up your lettering. It is very simple – you will see! You will need two brush pens of your choice (light and dark colours), as well as a black fineliner and a white gel roller.

STEP 1

WRITE A WORD USING THE LIGHTER COLOUR

PS: THE COLOUR TRANSITION SHOWN HERE WAS PRODUCED WHEN SCANNING THE IMAGE – BUT IT ALREADY LOOKS GOOD, DOESN'T IT? ;)

STEP 2

COLOUR IN THE LOWER HALF USING THE DARKER COLOUR. YOU CAN, OF COURSE, DRAW A LINE BEFOREHAND WITH A RULER TO HELP YOU.

STEP 3

Next, add some spots at the point where the two colours cross over or "blend". Reduce the number of spots as you go up.

STEP 4

You can insert small light reflections on the lettering using the white gel roller.

STEP 5

Finally, give your word a line of shadow using the black fineliner. Et voilà – you've done it!

Blending with brush pens

CHOOSE A LIGHT AND A DARK SHADE OF ONE COLOUR OR USE THE COLOURS OF THE RAINBOW AS A GUIDE. THE COLOURS THAT ARE NEXT TO EACH OTHER AUTOMATICALLY PRODUCE A HARMONIOUS COLOUR BLEND. E.G. PURPLE & BLUE, BLUE & GREEN, GREEN & YELLOW, YELLOW & ORANGE, AND ORANGE & RED.

Blending is the term used to describe the technique of mixing two or more colours to produce a beautiful colour gradation. You can achieve this using different methods. Regardless of the method of blending, however, you should be careful to choose colours that work in harmony with each other.

The starting point for blending is to take a light and a darker colour. Blending only works with water-based brush pens. The lighter colour is always the base colour and the darker colour is blended into it. The reverse process is not possible. Do not use very thin paper, since you sometimes have to work on individual areas several times over and thin paper becomes rough more quickly.

1 – 4 = horizontal blending
5 – 6 = vertical blending

 FROM TIP TO TIP

YOU CAN HOLD THE TIPS OF THE TWO BRUSH PENS DIRECTLY TOGETHER SO THAT THE DARKER COLOUR TRANSFERS TO THE LIGHTER ONE. WHILE YOU ARE WRITING THE COLOUR GRADUALLY CHANGES AND REVERTS TO THE ORIGINAL (BASE) COLOUR.

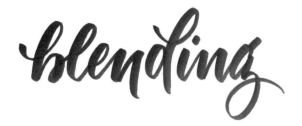

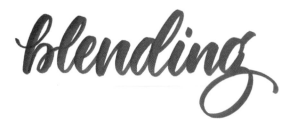

2 CLING FILM

PLACE A LITTLE COLOUR FROM THE DARKER PEN ON THE CLING FILM AND PICK UP THE COLOUR WITH TIP OF THE OTHER PEN. AS SOON AS THE LIGHTER COLOUR HAS VISIBLY ABSORBED THE DARKER ONE, YOU CAN START YOUR LETTERING.

3 LIQUID WATERCOLOUR PAINTS

BLENDING ALSO WORKS EXTREMELY WELL
WITH LIQUID WATERCOLOUR PAINTS. WITH
THESE, YOU CAN ACHIEVE THE SAME EFFECT
AS WITH THE ABOVE-MENTIONED METHODS.
SIMPLY DIP THE TIP OF THE BRUSH PEN
IN A POT OF LIQUID WATERCOLOUR PAINT.
DON'T WORRY, IT WILL NOT DAMAGE
YOUR BRUSH PEN AND CAN BE REMOVED
COMPLETELY AFTERWARDS.

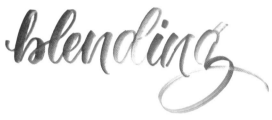

4 COLOURLESS BLENDERS* – VERSION 1

PLACE A LITTLE COLOUR FROM BOTH PENS
ON A PIECE OF CLING FILM AND FIRST
PICK UP ONE COLOUR WITH THE BLENDER
PEN. WRITE YOUR WORD WITH IT. IF YOU
LIKE, YOU CAN ALSO PICK UP THE SECOND
COLOUR AS WELL. THIS GIVES A LOVELY
EFFECT.

5 COLOURLESS BLENDERS* – VERSION 2

WRITE A WORD IN THE LIGHTER COLOUR.
PLACE SOME OF THE DARKER COLOUR ON A
PIECE OF CLING FILM AND PICK IT UP
WITH THE BLENDER PEN. NOW PAINT THE
DARKER COLOUR ON TO YOUR LETTERING
TEXT STARTING AT THE TOP OR THE BOTTOM
AND BLEND IT IN.

6 WATER AND BRUSH

FIRST WRITE A WORD OF YOUR CHOICE WITH
THE LIGHTER BRUSH PEN. THEN APPLY THE
DARKER COLOUR TO THE UPPER END OF THE
LETTERS AND CAREFULLY BLEND THE COLOURS
DOWNWARDS USING WATER AND A BRUSH OR
A WATER BRUSH. I RECOMMEND YOU USE
WATERCOLOUR PAPER FOR THIS. BE CAREFUL,
HOWEVER, OF FELT TIPS — IT IS BEST TO
USE OLD BRUSH PENS FOR THIS!

*E.G. FROM ECOLINE OR TOMBOW

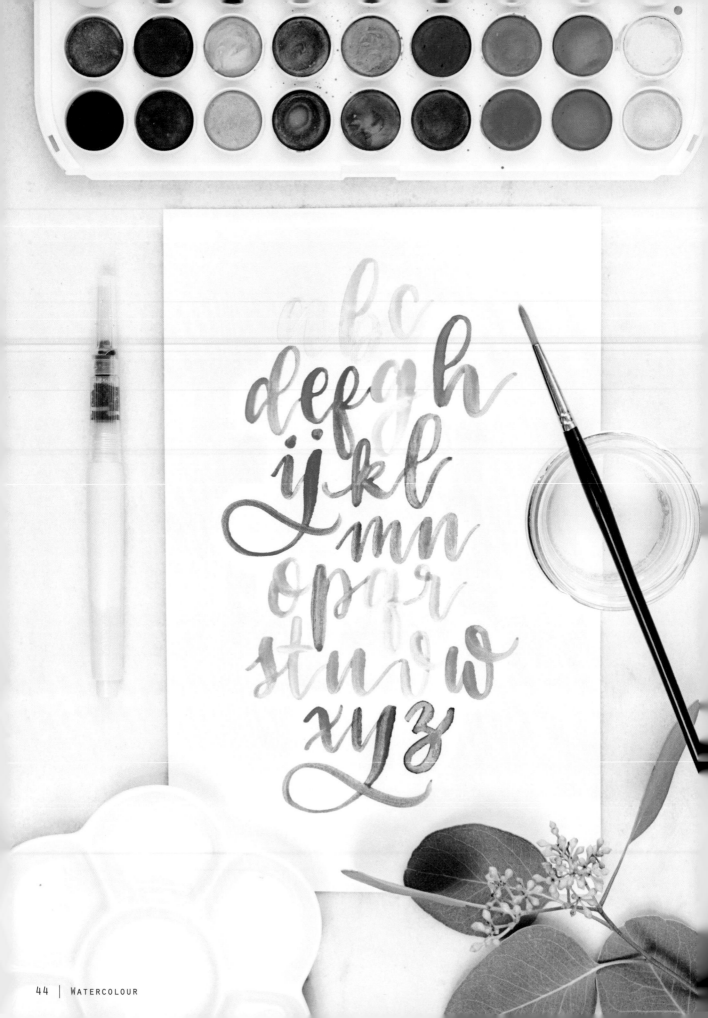

Watercolour

HAVING FOCUSSED ON BLENDING ON THE PREVIOUS PAGES, IT IS NOW TIME TO TAKE A LOOK AT WATERCOLOUR PAINTS. THERE ARE A LARGE NUMBER OF OPTIONS FOR COMBINING BRUSH LETTERING WITH WATERCOLOUR. I WILL SHOW YOU SOME LOVELY TEXT EFFECTS, SIMPLE ILLUSTRATIONS AND DIFFERENT BACKGROUNDS, WHICH NOT ONLY LOOK BEAUTIFUL BUT ARE ALSO VERY EFFECTIVE.

You can create real works of art from your lettering projects using watercolour. It is great fun to work with the different techniques, constantly trying out new colours and shapes and seeing what the final results are. What fascinates me most is that it is possible to create lovely things even if you do not have much talent for drawing (and unfortunately I am included in this group of people). A dab of paint here, a drop of water there and a lovely colour progression is created, along with flowers and leaves, wonderful textures and, of course, lettering texts. What seems complicated at first glance is actually not so difficult, once you know what is involved.

The wonderful thing about watercolour paints is that you yourself can determine how transparent they appear – depending how much water you add, you can produce different shades and nuances of colour. And apart from that, I also find that mixing colours is very exciting and yet relaxing. Just give it a try.

– SEE PAGE 48

LOTS OF WATER, LITTLE PAINT

EQUAL AMOUNTS OF WATER AND PAINT

LITTLE WATER, LOTS OF PAINT

The colour chart
Get to know your colours

Regardless of the brand chosen, all watercolour paints have a specific name and/or number. However, at first glance it is not always possible to determine what the colours will actually look like on your paper. The illustration on the packaging merely serves as a guide. I therefore recommend that you create a colour chart for every range of paints you have – whether these come in tubes, liquid form or in palettes.

What to do:

Use a sheet of any watercolour paper of your choice. Divide the required area into the same number of columns and rows as you have in your colour palette. Gradually apply the colours in the same order as in the palette. If you cut the colour chart so that it fits into your paint box, you will always have it ready to hand. For tubes or liquid watercolour paints you can include as many squares as you have colours. You can also add a few blank squares in case you want to extend your colour range at a later date.

TIP:

THE BOTTLES OF NEW LIQUID PAINTS FROM ECOLINE NOW COME WITH AN INTEGRATED PIPETTE, WHICH I PERSONALLY THINK IS A GREAT IDEA! THE FOLLOWING TIP THEREFORE ONLY APPLIES TO THE OLD BOTTLES:

CUT CIRCLES OUT OF WATERCOLOUR PAPER, PAINT THEM WITH THE COLOUR AND THEN STICK THEM ON THE LIDS OF THE RESPECTIVE BOTTLES.

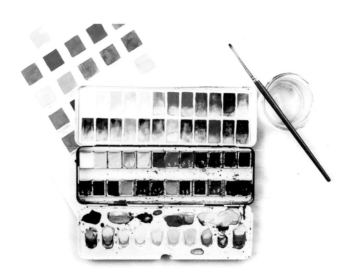

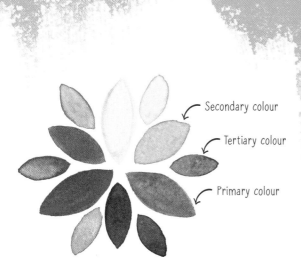

Secondary colour

Tertiary colour

Primary colour

Colour theory is based on the three **primary colours**: yellow, red and blue. If you mix these colours together, you obtain the **secondary colours**: orange, green and purple. If you once again mix these with the primary colours you obtain six more colours, known as the **tertiary colours**, and so on. You can thus mix an endless number of colours and, theoretically, you should not need to purchase an extensive colour palette. ;) HOWEVER, mixing specific shades of colour entails a loooot of practice. You can start with a basic stock of pure colours, however, without first having to find the right mixing ratio for colours.

You can also change the intensity and saturation of pure colours. By adding white, you can make colours lighter or more pastel and you can make them darker by adding grey. Here is an example of this:

WHITE

IS NOT OPAQUE IN THE CASE OF WATERCOLOUR PAINTS! YOU CAN, HOWEVER, MIX WHITE WITH OTHER COLOURS AND CREATE PASTEL SHADES.

BLACK

IS NOT PARTICULARLY SUITABLE FOR MIXING COLOURS, SINCE IT ONLY PRODUCES "DIRTY BLACK" COLOUR BLENDS. IF YOU WANT TO MAKE A COLOUR DARKER, YOUR BEST OPTION IS TO USE GREY.

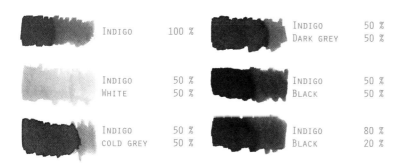

INDIGO	100 %	
INDIGO / WHITE	50 % / 50 %	
INDIGO / COLD GREY	50 % / 50 %	
INDIGO / DARK GREY	50 % / 50 %	
INDIGO / BLACK	50 % / 50 %	
INDIGO / BLACK	80 % / 20 %	

Mixing colours

CREATING COLOUR CODES

MIX YOUR COLOURS AS NEEDED AND PREPARE A CORRESPONDING COLOUR CHART ON A PIECE OF SCRAP PAPER.

THIS ALLOWS YOU TO SEE AT A GLANCE WHETHER THE MIXING RATIO IS APPROPRIATE, HOW THE COLOURS LOOK ON THE PAPER AND IF THEY PRODUCE A HARMONIOUS BLEND.

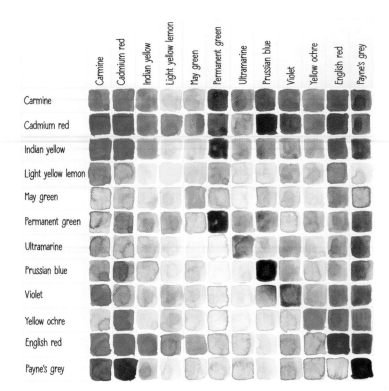

TIP!

ALWAYS MIX UP A LARGE ENOUGH QUANTITY OF PAINT SO THAT IT DOES NOT RUN OUT WHILE YOU ARE PAINTING/DRAWING, SINCE IT IS NOT EASY TO MIX EXACTLY THE SAME COLOUR AGAIN – APART FROM THE FACT THAT THIS DISTURBS YOUR WORKFLOW.

Admittedly, mixing colours is not very easy. It becomes easier, however, the more often you do it, since you get a feel for mixing colours by practising a lot. But until you reach this stage, there is a solution. I created my own colour chart, for example, with a selection of colours. Simply mix each colour with all of the others. It takes a little time and patience, but in any case it is great fun. The very process of mixing the different colours and then seeing which new colours are created is quite exciting (and relaxing).

Once it is finished, you have a colour chart that will always serve you as a guide. You can see at a glance which base colours you need to mix for a desired shade of colour. Of course, it also depends on the mixing ration of the two colours and the amount of water added. But it does at least give you a clue – and a very good one, in my opinion!

There are various painting techniques, which allow you to create different effects.

WASHING

When using the technique known as a 'wash', the paint is diluted with water, which makes the tonal value lighter. With water, you can "thin out" or make the colour "fade", as it were, creating a lovely colour transition.

GLAZING

Watercolour paints are not opaque; when using the technique known as 'glazing', therefore, colours are applied on top of one another in layers in order to intensify the pigment (darkening the tonal value). It is important that the individual layers of colour are completely dry so that they do not "run" into each other.

WET-ON-WET

When using the wet-on-wet technique, the painting surface involved is first dampened with water. This may be the entire sheet of paper or only a part of it. The paper should not be too wet, just slightly shiny. After that the paint is applied (in drops or using brushstrokes) and instantly spreads across the dampened surface. You can also add a second colour to an area of colour that is still wet.

WHITE SPACE

White spaces are important in watercolour painting as they add more drama to your illustration. White areas are not painted with opaque white, however, but are left blank. There are different methods of doing this. You can leave the areas completely blank (by painting round them) or protect the desired areas from paint using various means (e.g. masking fluid or wax crayon).

Text effects with watercolours

In lettering with watercolours it is also a case of making thin upward and thick downward strokes. However, compared to the brush pen, you now have two additional components that you need to consider. On the one hand, you have the brush with individual bristles, which you have to keep under control, and on the other, you are working with a liquid painting medium (paint + water), which needs to be repeatedly picked up with the brush. But the good thing about watercolour lettering is that you can let the colours "flow" through a word. On the following pages I will show you what great techniques there are to do this.

BLEEDING VS. BLENDING

There are basically two alternative ways of creating a colour change within your watercolour lettering text. The term "bleeding" refers to the technique of randomly merging at least two colours. Be careful that the point where the two colours are to meet is damp enough so that the colours can mix well. With this technique you do not really have control over what the colour transition will look like. With blending, on the other hand, the wet paints are blended together with a brush and water, so that the colour transition created is as homogeneous as possible. This can sometimes be very time-consuming. In any case, make sure you use enough water when you are blending, so that the colours can run well, since this is the only way to create a pretty colour progression at the point where the colours meet.

TIP:

When selecting your colours, make sure that the colours you choose are harmonious and go together well. The best thing to do is to test the colour combination in advance on a piece of scrap paper.

BLEEDING

BLENDING

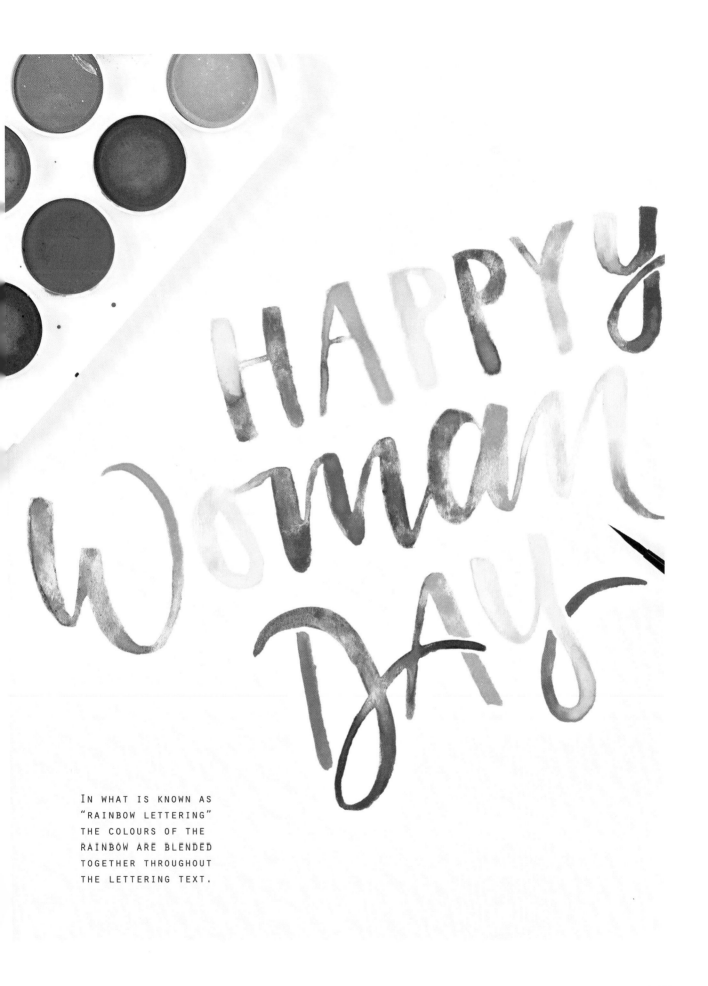

IN WHAT IS KNOWN AS
"RAINBOW LETTERING"
THE COLOURS OF THE
RAINBOW ARE BLENDED
TOGETHER THROUGHOUT
THE LETTERING TEXT.

Blending with watercolours

Choose two or more harmonious colours and make sure you use watercolour paper for your blending so that the paper does not warp too quickly. Ultimately, you need to work with a lot of water and paint for all these alternative ways of blending, in order to create beautiful effects.

TONAL GRADATION (SINGLE COLOUR)

Tonal value is the term used to describe the different degrees of a colour between dark and light. For this vertical transition, you start with plenty of paint (colour pigment) and it becomes lighter and lighter towards the end as you add more and more water. You can also start very light and add more and more colour towards the end.

TWO-COLOUR GRADATION

Here, you once again start with the lighter colour and you create the progression by applying the darker colour in selected spots — either at the top or the bottom of your text while it is still wet. After that, you blend the two colours together. It is important to work quickly because the transition only works well when the colours are damp.

BLEEDING IN SELECTED SPOTS

First write the word you want in a lighter colour. While the paint is still wet apply spots of the darker colour at selected intervals. You can also add other colours, but make sure you always start with the lightest colour. This creates a rather irregular but at the same time dramatic mix of colours.

BRUSHO (PAINT PIGMENTS)

You can apply these water-based paint pigments to a wet surface. You can add the pigments to letters drawn in advance either with clean water or with liquid watercolour paints. It is great fun to see how the colours disperse and blend in individually.

SPLATTERS OF COLOUR

You can also create lovely effects with simple splatters of colour. To do this, write your word in one colour, taking care that the letters are very wet. Select another (darker) colour and add sprinkles of colour by tapping carefully on your brush with your index finger. Make sure that your workspace around the text is well protected; otherwise you may find you have sprinkles where they are not supposed to be ;).

 TIP:

EMBOSSING POWDER

YOU CAN ADD REALLY LOVELY, TEXTURAL GLITTER EFFECTS
TO YOUR WATERCOLOUR LETTERING USING EMBOSSING POWDER.
SPRINKLE THE POWDER ON TO THE PAINTED LETTERS WHILE
THEY ARE STILL WET AND MELT IT UNDER A HOT FLOW OF AIR
(USING A HAIR DRYER).

More text effects

METALLIC EFFECT

YOU CAN ADD PARTICULARLY ELEGANT EFFECTS TO YOUR LETTERING USING METALLIC PAINTS, LIKE THE ONES PRODUCED BY FINETEC FOR EXAMPLE. USE THESE PAINTS FOR BLENDING IN A SIMILAR WAY TO OTHER WATERCOLOURS. TRY OUT DIFFERENT ALTERNATIVES AND YOU WILL SEE THAT REALLY MAGICAL THINGS OCCUR.

GALAXY LETTERING

WITH THIS TECHNIQUE YOU DRAW YOUR LETTERS IN ADVANCE WITH PLENTY OF WATER. WHEN THE ENTIRE TEXT IS REALLY WET YOU ADD TWO OR MORE COLOURS IN SELECTED SPOTS. THE COLOURS THEN RUN INTO EACH OTHER AT RANDOM ON YOUR WET SURFACE. ONCE EVERYTHING IS COMPLETELY DRY YOU CAN ADD EFFECTS WITH A WHITE GEL ROLLER.

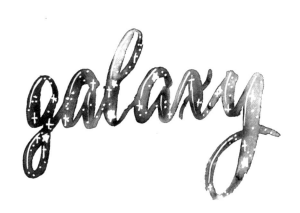

LINED SCRIPT

YOU CAN FURTHER JAZZ UP YOUR WATERCOLOUR LETTERING USING A VERY SIMPLE TRICK. WRITE YOUR WORD AND REINFORCE ALL THE DOWNWARD STROKES WITH A SECOND, THINNER LINE. THIS ADDS DRAMA TO YOUR LETTERING AND DOES NOT TAKE TOO MUCH EFFORT TO CREATE.

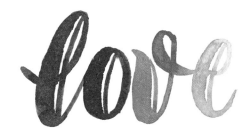

Watercolour backgrounds

If you want to create watercolour backgrounds for simple black text, there are two options. Either you do the background first and place the text on it, or vice versa. Both are possible. For the second alternative, however, it is crucial that you use a waterproof pen or waterproof paints, otherwise the background (which you produce with water, after all) will inadvertently blend with the text and this may destroy your artwork.

You can create really lovely backgrounds using different techniques, ranging from a textured, single colour right through to multi-coloured homogeneous colour transitions. First of all, however, I will show you some alternatives in a single colour with different textures.

TIP:

YOU CAN EASILY TEST WHETHER THE PAINTS OR PEN THAT YOU ARE USING FOR YOUR TEXT IS WATERPROOF OR NOT — SEE PAGE 15.

DRY BRUSH TECHNIQUE

DAMPEN YOUR BRUSH WITH WATER AND PICK UP SOME PAINT. WIPE MOST OF THE PAINT OFF THE BRUSH AGAIN BEFORE PAINTING THE BACKGROUND. IT IS BEST TO USE COLD PRESSED PAPER, SO THAT YOU OBTAIN A BEAUTIFUL STRUCTURE. THIS WORKS BEST WITH A FLAT BRUSH.

WET-IN-WET TECHNIQUE

FIRST OF ALL, USING THE BRUSH, APPLY CLEAN WATER TO YOUR PAPER. THEN PICK UP SOME PAINT AND APPLY IT TO THE DAMP (NOT TOO WET) AREAS, AND ALLOW THEM TO DRY. THEN, JUST LET YOURSELF BE SURPRISED, BECAUSE THE RESULT, ONCE DRY, LOOKS COMPLETELY DIFFERENT TO WHEN IT IS WET.

SPRAY AND PAINT

TAKE A SPRAY BOTTLE OF CLEAN WATER AND DAMPEN THE PAPER. THEN PICK UP SOME PAINT ON YOUR BRUSH AND DAB IT CAREFULLY ON TO THE WET SURFACE. IT IS FASCINATING TO SEE HOW THE COLOUR SPREADS OUT ON THE PAPER.

PAINT AND SPRAY

WITH THIS VERSION, YOU DO THE EXACT OPPOSITE. FIRST PAINT THE BACKGROUND AND LET THE PAINT DRY A LITTLE. THEN SIMPLY SPRAY THE AREA WITH CLEAN WATER. BE CAREFUL, HOWEVER, NOT TO SPRAY TOO MUCH, OTHERWISE PUDDLES OF WATER WILL QUICKLY FORM.

SALT

COMMON SALT CAN PRODUCE VERY DRAMATIC, CRATER-LIKE EFFECTS. PAINT YOUR BACKGROUND WITH A COLOUR OF YOUR CHOICE AND ADD THE SALT WHILE THE PAINT IS STILL WET. LEAVE THE AREA TO DRY AND THEN SIMPLY SCRATCH/WIPE THE SALT OFF.

CELLOPHANE PAPER

THIS METHOD CREATES A GEOMETRIC TEXTURE. PAINT YOUR BACKGROUND IN THE COLOUR OF YOUR CHOICE. TAKE A PIECE OF CELLOPHANE AND CRUMPLE IT A LITTLE. THEN PRESS THE CRUMPLED CELLOPHANE ON TO THE SURFACE WHILE IT IS STILL DAMP. WEIGH IT DOWN WITH A BOOK AND LEAVE IT TO DRY.

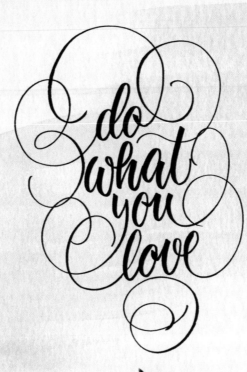

do
what
you
love

CLEAR PLASTIC SLEEVE/ DOCUMENT POUCH

APPLY YOUR PAINT TO THE CLEAR PLASTIC SLEEVE. TURN THE SLEEVE OVER AND LAY IT ON YOUR PAPER. NOW YOU CAN DISTRIBUTE THE PAINT BY STROKING YOUR FINGERS OVER THE SLEEVE. FINALLY, ALLOW THE PAINT TO DRY WITH THE PLASTIC SLEEVE STILL IN PLACE. (SEE ALSO PAGE 61)

DRINKING STRAW

YOU PROBABLY REMEMBER THIS TECHNIQUE FROM YOUR CHILDHOOD. IT IS SIMPLE, YET EFFECTIVE. PUT A DAB OF VERY WET PAINT ON YOUR PAPER AND BLOW THE LIQUID IN ALL DIRECTIONS WITH THE DRINKING STRAW. THIS CREATES ATTRACTIVE STREAKS OF COLOUR.

BRUSH

YOU CAN TAKE PAINT OFF AGAIN WHILE IT IS STILL WET USING A BRUSH. DIP YOUR BRUSH IN CLEAN WATER AND STROKE IT OVER THE PAPER TO REMOVE THE PAINT. REPEAT THE PROCEDURE AS OFTEN AS YOU LIKE, UNTIL YOU HAVE CREATED THE DESIRED TEXTURE OR PATTERN.

MASKING FLUID

YOU CAN DRAW ANY PATTERN OR EVEN LETTERING YOU LIKE USING MASKING FLUID OR A MASKING PEN. LET THE MASKING FLUID DRY AND THEN PAINT THE DESIRED BACKGROUND OVER IT. ONCE THE PAINT IS DRY, YOU CAN SIMPLY RUB AWAY THE MASKING FLUID WITH YOUR FINGER.

Do More of What Makes You Happy ♥

COLOUR GRADATIONS/BLENDING

You can also create lovely areas of two or more colours using watercolour paints. To do this, the desired colours are blended together. This technique is very useful as a warm-up exercise and to see how watercolour paints react in the various different methods of blending.

TONAL GRADATION (SINGLE COLOUR)

PAINT A VERTICAL BAR OF COLOUR. THEN WASH YOUR BRUSH OUT AND LOAD IT WITH WATER. PLACE YOUR BRUSH ON THE BAR OF COLOUR THAT IS STILL DAMP AND "DRAG" THE COLOUR TO THE RIGHT BY MAKING REPEATED UPWARD AND DOWNWARD MOVEMENTS, UNTIL THE TONAL VALUE BECOMES INCREASINGLY LIGHT. THIS ALSO WORKS WITH A HORIZONTAL STRIPE OF COLOUR WORKING FROM TOP TO BOTTOM.

TWO-COLOUR GRADATION

PAINT A BAR WITH THE FIRST COLOUR. BEGIN WITH THE SECOND COLOUR ON THE OPPOSITE SIDE. THEN BLEND THE TWO COLOURS IN THE MIDDLE USING LOTS OF WATER UNTIL YOU HAVE A HOMOGENEOUS COLOUR GRADATION.

THIS ALSO WORKS VERY WELL USING THE SPLATTERING TECHNIQUE.

COLOUR GRADATION IN SELECTED SPOTS

PAINT AN AREA OF PAPER WITH THE LIGHTER COLOUR. PICK UP SOME OF THE DARKER COLOUR WITH YOUR BRUSH AND DAB INDIVIDUAL SPOTS OF PAINT ON TO THE SURFACE WHILE IT IS STILL DAMP. YOU CAN ALSO APPLY CLEAN WATER INSTEAD OF PAINT TO THE SURFACE AND CREATE A SINGLE-COLOURED BACKGROUND.

BLENDING WITH BRUSH PENS

TAKE A PLASTIC BAG OR PIECE OF CLING FILM AND PAINT SOME SPOTS OF COLOUR ON IT AT RANDOM USING WATER-SOLUBLE BRUSH PENS. THEN SPRAY SOME CLEAN WATER ON THE BAG/FILM OR THE PAPER USING A SPRAY BOTTLE. TURN THE FILM OVER AND PRESS IT ON TO THE PAPER. NOW YOU CAN "SPREAD" THE COLOUR WITH YOUR FINGERS. FINALLY, REMOVE THE FILM AND LEAVE YOUR WORK TO DRY.

Chris

Katie

Verena

Sabine

Mike

Julian

Sonja

NAME CARDS

If you are making name cards, for example, you can get really artistic with different blending techniques and you can also use them in combination. The most important thing is to have a consistent colour concept. Here, I have chosen two colours and the following three methods of blending:

TONAL GRADATION
(SINGLE COLOUR)

FOR THIS VERSION,
YOU SIMPLY PAINT
A FEW HORIZONTAL LINES
OF COLOUR ON YOUR
PAPER AND BLEND THESE
TOGETHER AFTERWARDS
WITH WATER. IF
NECESSARY, YOU CAN
ALSO ADD HIGHLIGHTS
WITH FURTHER LINES OF
COLOUR.

TWO-COLOUR VERTICAL
GRADATION

First, cut your cards to the desired size out of watercolour paper and create your backgrounds using different methods of blending. Leave the paint to dry thoroughly. If the cards curl up too much afterwards, you can dampen them again slightly on the reverse side once they are dry, weigh them down (e.g. between two books) and leave them to dry like this. If they curl slightly it doesn't matter; the cards are handmade after all, and you are allowed to see this.

When the cards are dry, you can write on them. I like to use brush pens with nylon tips for this, since they are not so sensitive. The paper I have chosen has a very coarse surface and would ruin brush pens with felt sponge tips straight away.

PRODUCTS USED

FABRIANO ARTISTICO EXTRA
WHITE GRANA GROSSA ROUGH

ECOLINE LIQUID WATERCOLOURS
No. 381 PASTEL RED
No. 579 PASTEL PURPLE

ROUND BRUSH
ART MAKER NO. 12

TOMBOW FUDENOSUKE HARD TIP

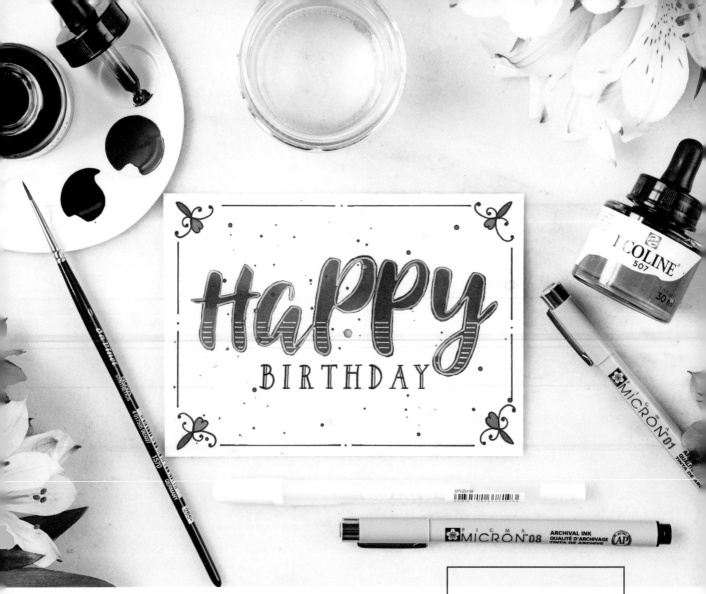

BIRTHDAY CARDS

You can also create really pretty brush lettering cards with the watercolour blending technique.

Whether you carry out all the steps right to the end is up to you - if you already like the watercolour lettering with the blending technique, you can stop after blending the colours or use other effects. The frame is also a matter of taste. There are simply infinite possibilities and tricks you can play around with.

With that in mind, have fun experimenting!

HaPPy
BIRTHDAY

Design the lettering with a brush pen or fineliner. Use a sheet of paper that is suitable for your brush pen.

Transfer this template to your watercolour paper using a pencil. Use a light pad or trace the template on a windowpane.

HaPPy
BIRTHDAY

Then you can paint the areas of the letters with the liquid watercolours. Make sure that the gradations are smooth and homogenous.

HaPPy
BIRTHDAY

While the colour is drying, you can go over the lower lettering with a fineliner and refine it with various stylistic effects.

HaPPy
BIRTHDAY

When the blended lettering is dry, you can add further effects with the white gel roller pen - such as inside contours or a lined effect.

After that, sketch in the border with a pencil and go over it with a fineliner. Then paint the corner motifs with watercolours and finally add a few sprinkles of colour.

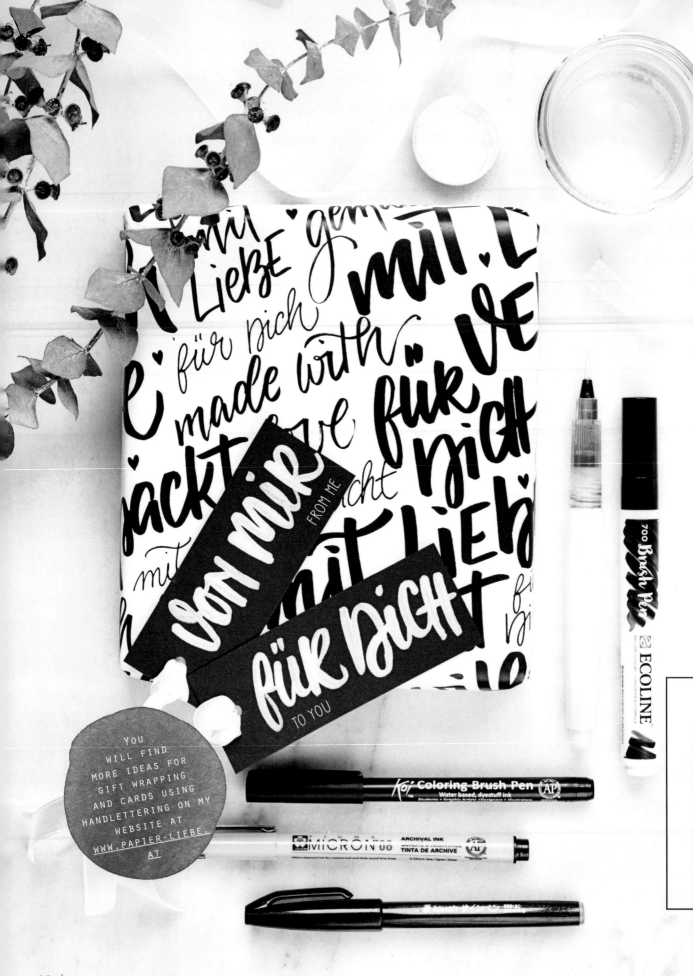

FROM ME

TO YOU

YOU WILL FIND MORE IDEAS FOR GIFT WRAPPING AND CARDS USING HANDLETTERING ON MY WEBSITE AT WWW.PAPIER-LIEBE.AT

GIFT WRAPPING PAPER AND GIFT TAGS

You often need gift wrapping paper and matching gift tags, don't you? Not only do they look good if you create them using hand lettering, but they are also unique and it does not take long to make them. There are no limits placed on your imagination here.

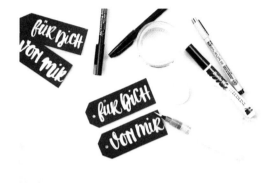

Gold, black & white is also a fantastic combination.

Simply take a sheet of paper that is big enough to wrap your gift and grab a few different pens. They don't necessarily need to be just black pens – bright colours and/or different watercolour backgrounds look good for this too.

Write a selection of different words on your paper. You can combine various fonts and styles of lettering. It doesn't matter if it looks a bit muddled. The paper with its lettering may look a little unstructured as a whole ... I often think to myself: "I could have set it out better or written it on one line." But don't worry, once the gift is wrapped up in the paper with your hand lettering, the "wow" effect will come of its own accord.

To make the matching gift tags, I used black card and did the lettering with white metallic paint using a brush with a water reservoir. You can, of course, vary the styles and colours.

VERWENDETE PRODUKTE

A3 COLOUR COPY PAPER FOR LASER PRINTERS, 100GSM

ECOLINE BRUSH PEN
KOI COLOURING BRUSH PEN
PENTEL TOUCH SIGN PEN
PIGMA MICRON 08

ILLUSTRATED PAPER BLACK

SAKURA WATER BRUSH SMALL

PRIMA MARKETING INC
METALLIC WATERCOLOUR WHITE
NOISE

von mir ♥ für Dich

"FROM ME TO YOU"

ABSTRACT WATERCOLOUR LEAVES

These leaves are very easy to create. It is not a question of working on fine details, but of using the brush correctly. With a few simple strokes, I will show you how you can easily achieve the results of the projects shown on the following pages.

The black arrows show you the direction of the brush. Start at the black dot in each case. Place the tip of your round brush on the paper and press the brush tip down firmly for thick areas. For thin lines remove the pressure. If you work with a dry brush, you create more structure to your leaves; with a damp brush, on the other hand, you achieve more colour contrast.

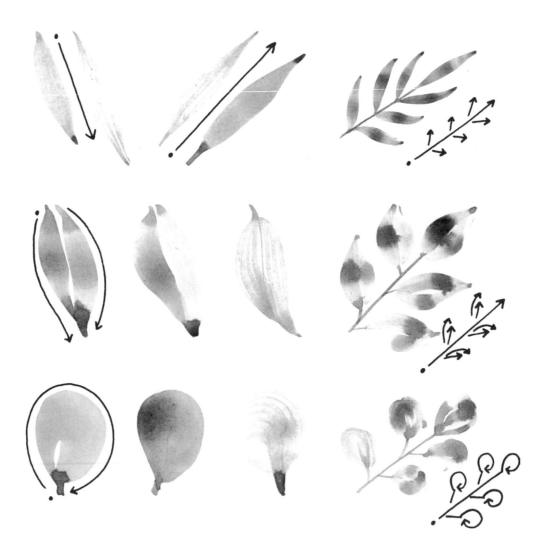

WATERCOLOUR ROSE ABSTRACT

In this step-by-step guide, I will show you how you can paint simple rose blossoms, for example. Start with a dark colour (more colour pigment) at the centre of the rose. You can also augment the darker contrasts when you are in the process of painting by adding colour while the surface is still wet and using the blending technique. This creates a very natural progression.

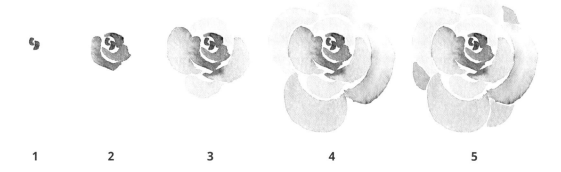

1 **2** **3** **4** **5**

You can also deliberately blend parts of the petals into one another, since it is not a matter of tiny details in the case of an abstracted rose either.

WHAT TO DO:

First of all, start with two intertwined 'C' shapes **(1)** and add a few petals around them using crescent-shaped brush strokes **(2)**. Repeat the process until the flower is the size you want **(3)**. Make sure that the rows of petals are not only lighter and larger as you go outwards, but that they are offset in relation to each other **(4)**. Finally, add a few more small petals at the outer edge of the flower to complete your rose **(5)**.

YOU WILL FIND MORE IDEAS FOR WATERCOLOUR FLOWERS AND LEAVES ONLINE AT

WWW.PAPIER-LIEBE.AT/WATERCOLOR

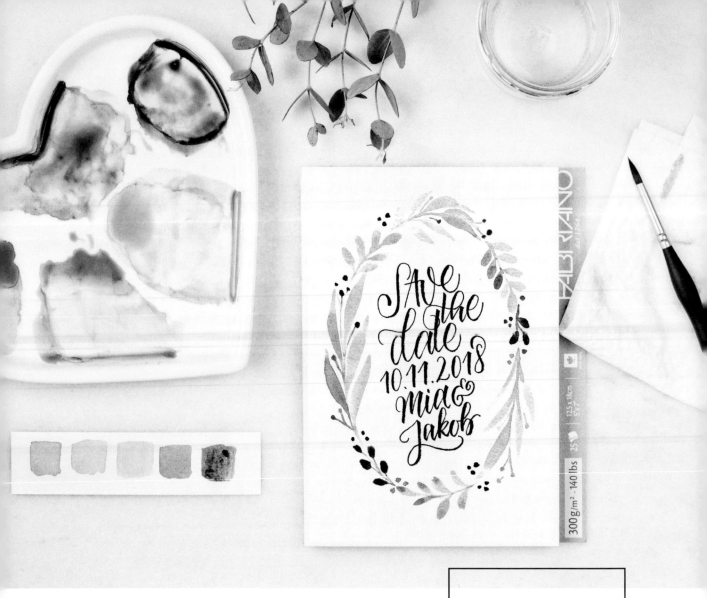

SAVE THE DATE „GREENERY"
Watercolour leaves combined with brush lettering

First of all, think about the shape of your card and the desired text and make a rough sketch. Instead of the oval shape, for example, you can also choose a circle, a hexagon or any other shape. This basic form sets out the structure for your text and leaves. You can also mix different font styles to give your lettering an attractive appearance.

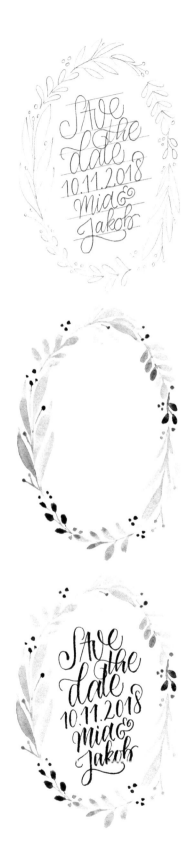

Then you create a design for the arrangement of your leaves, which you will paint with watercolours at a later stage. When you finally apply the colours you have some leeway, of course – this just serves as guidance. Make sure the layout of your leaves is well-balanced.

In the next step, you create the lettering you require and decide on the positioning of your text. Draw some guide lines, so that your lettering is set out in a balanced way. This process will definitely require a few revisions and I recommend that you use tracing paper, which you can repeatedly lay over your design and improve it.

Once you are satisfied with your design, you can transfer it to your watercolour paper using very subtle pencil lines, since it may be impossible to erase the lines once you have painted over them with watercolours.

Then, mix the colours. I mixed various shades of green, brown and grey from my colour palette and then created my colour swatches on a scrap piece of watercolour paper. Like this, I can keep all my colours in view and I can integrate them better into my illustration.

Now it is time to paint the leaves. Start with one sprig, paint the stem and add the individual leaves one after another. Complete the garland piece by piece. To create a balanced layout, I added some small spots of paint at the end to represent berries.

Once it is finished, leave the painting to dry thoroughly. Only afterwards can you add the text with the brush pen. In this case too, it may be a good idea to write the text on a separate sheet of paper first, so that you become familiar with the pen and the way of writing the words. Finally, erase any visible pencil marks and your work is completed.

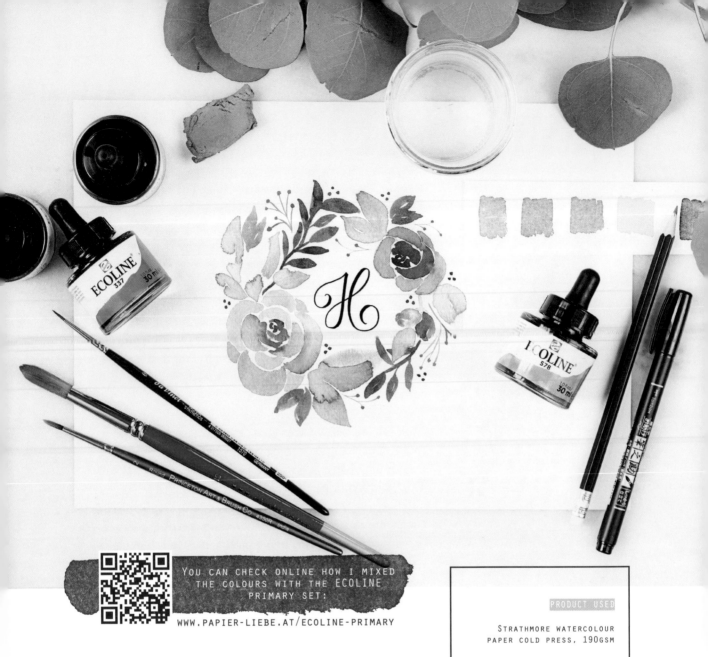

You can check online how I mixed the colours with the Ecoline primary set:

www.papier-liebe.at/ecoline-primary

PRODUCT USED

Strathmore watercolour paper cold press, 190gsm

ECOLINE liquid watercolour Primary set

Round brush
da Vinci Nova synthetic no.0
Princetown art & brush co. No. 2
Art maker no.12

Fudenosuke hard tip

MONOGRAM WITH GARLAND OF FLOWERS
Watercolour leaves and flowers combined with brush lettering

Start with a circle as your basic shape. Sketch this very lightly with a soft pencil on your piece of paper. Then erase most of the lines again, so that you just have a few discreet reference marks to indicate the circle. The fewer pencil lines you have, the better, for as you already know, it is seldom possible to remove these lines once they have been painted over with watercolours.

Once again, if necessary, create a design for the arrangement of your flowers and leaves. Make sure, in any case, that your flower garland is well-balanced and start by dividing the flowers up along the pencil line you have sketched.

If you have not already done so, you should now think about colour combinations and mixing your colours, for in the next step, you paint the rose petals and rosebuds using a round brush (e.g. No. 2).

After that, add the light green rose leaves with a larger round brush (e.g. No. 12).

When painting the leaves, try to use different shades of green as this makes the arrangement more dramatic. At the next stage therefore, add the dark leaves, again using a smaller round brush (e.g. No. 2).

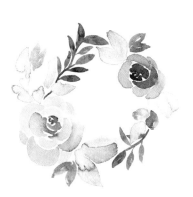

Paint a few more berries and/or fruits so that the garland looks well-balanced and rounded. You can simply use these as "fillers" and add them in areas where there is still too much space. It is best to paint the delicate berries with a very small round brush (e.g. No. 0).

Then leave your flower garland until it is thoroughly dry and subsequently erase the remaining pencil lines – if any of them are still visible.

The last step is to add the monogram to your flower garland. This can be a single letter or you can also link two initials together, for example. That would be perfect for a wedding invitation or similar occasion. For this example, I have chosen a single 'H' and set it in the middle of the flower garland using a brush pen.

This type of flower garland can also be painted much bigger, of course, so that you can add a saying or some other phrase, for example.

Text on cards:
"Let sparks fly"

You are welcome to download the template for the lettering on the sparkler cards from my website:

www.papier-liebe.at/sternspritzer

SPARKLER CARDS

Sparklers are often a highlight at weddings and other festivities. You can easily make the cards for them yourself using watercolours and brush lettering.

CUT CARDS MEASURING 6 X 8.5 CM* FROM WATERCOLOUR PAPER AND ADD A FEW DROPS OF WATER TO THE CENTRE OF EACH CARD USING A WATER BRUSH.

USING WATER-BASED BRUSH PENS, PLACE A LITTLE PAINT ON A PIECE OF CLING FILM OR A DOCUMENT POUCH - OR YOU CAN JUST AS EASILY USE A FREEZER BAG.

TURN THE CLING FILM OVER AND PRESS IT ON YOUR PAPER. AS IT COMES INTO CONTACT WITH THE WATER THE PAINT IMMEDIATELY BECOMES RUNNY AND YOU CAN SPREAD IT OUT AT RANDOM WITH YOUR FINGERS.

REMOVE THE CLING FILM AND REPEAT THE PROCEDURE UNTIL YOU ARE SATISFIED WITH THE RESULT. LEAVE THE CARD TO DRY THOROUGHLY.

NOW YOU CAN ADD YOUR TEXT WITH A WATERPROOF BRUSH PEN. IF YOU CREATE A DARK BACKGROUND YOU CAN WRITE YOUR TEXT WITH A WHITE GEL ROLLER, FOR EXAMPLE.

NOW CUT OFF THE CORNERS OF THE CARD AT A 45⊠ ANGLE AND PUNCH A HOLE AT THE TOP AND THE BOTTOM WITH A HOLE PUNCH. YOU CAN THEN FURTHER EMBELLISH THE CARD WITH LITTLE DOTS — E.G. USING GOLD, SILVER AND WHITE GEL ROLLERS.

PRODUCTS USED

ECOLINE LIQUID WATER COLOUR PAPER, 290GSM

SAKURA KOI WATER BRUSH

ECOLINE BRUSH PENS E.G. NO. 337, 507, 236

SAKURA GELLY ROLL WHITE, SILVER, GOLD

FUDENOSUKE HARD TIP

TIP:

BEFORE YOU START, PLACE A PIECE OF KITCHEN ROLL UNDERNEATH YOUR CARD TO CATCH THE EXCESS PAINT, SO THAT YOUR WORK SURFACE STAYS REASONABLY CLEAN.

*FOR JUMBO SPARKLERS

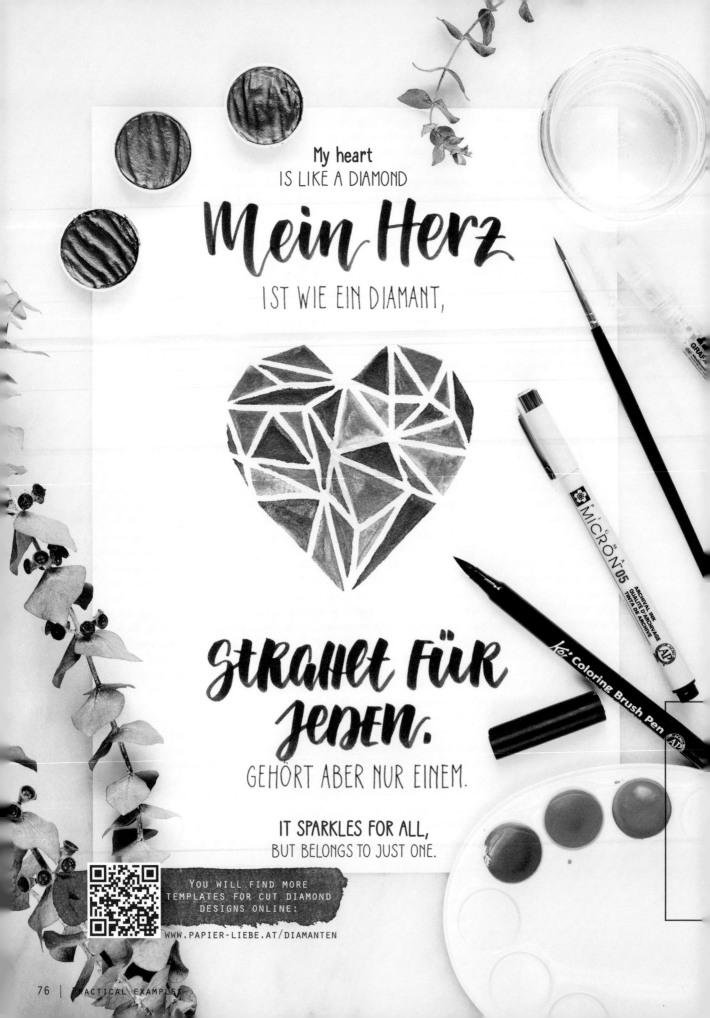

CARD/POSTER WITH SAYING

For this saying, you first of all sketch the basic heart-shape lightly in pencil and then go over the lines with masking fluid. After that you let it dry - but that does not take long.

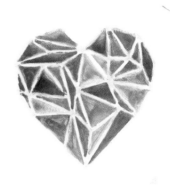

You can now paint over the areas inside the heart with the colour of your choice. I have chosen three different pearlescent colours, since they suit the theme very well. You can also use just one colour and lighten it by adding a larger or smaller quantity of water. The important thing is to have a little colour contrast in order to create the diamond effect.

Once you have finished painting you need to leave the colours to dry thoroughly. It is better to wait a little longer at this point, since it would be a pity if the heart was smudged as a result of removing the masking fluid too early.

In the meantime, you can think about the style of lettering and the arrangement of your text. I have chosen a mixed cursive script (mixture of upper and lower case letters) written with a brush pen and sans serif block capitals using a fineliner. Combinations of different scripts always make a text look more dramatic.

Once everything is completely dry, you can rub off the masking fluid with your finger or using an eraser. It looks good, doesn't it? Now you can also add your text to the card and then give it to someone as an attractive gift, or keep it for your own enjoyment.

PRODUCTS USED

CLAIRFONTAINE PAINT ON MULTI-TECHNIQUES

GRAFX™ MASKING LIQUID

FINETEC PEARL COLOURS BLACKBERRY, PINK, RED VIOLET

WINSOR & NEWTON BRUSH SERIES 7, SIZE 1

KOI COLORING BRUSH PEN

PIGMA MICRON 05

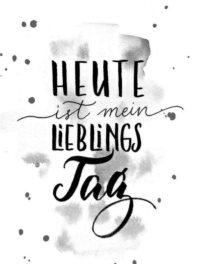

TODAY is my FAVOURITE Day

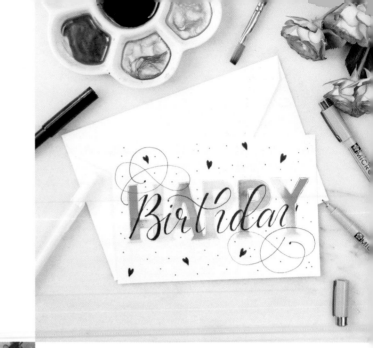

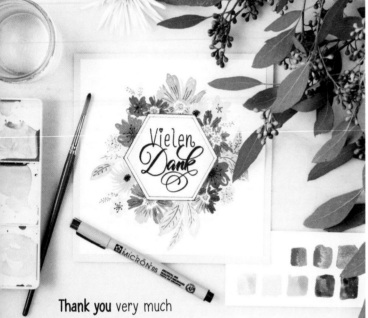

Thank you very much

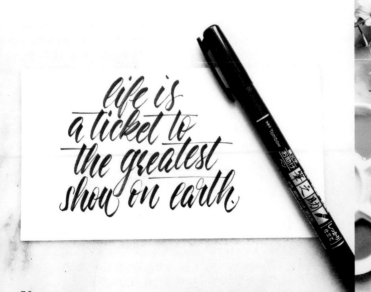

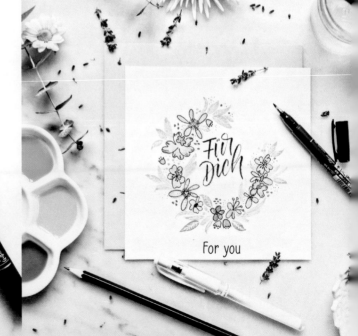

For you

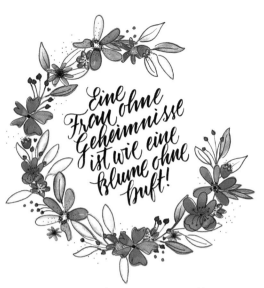

Eine Frau ohne Geheimnisse ist wie eine Blume ohne Duft!

A woman without secrets is like
a flower without scent!

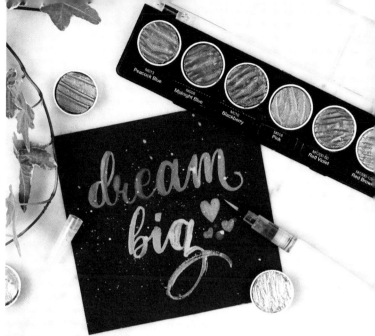

dream big

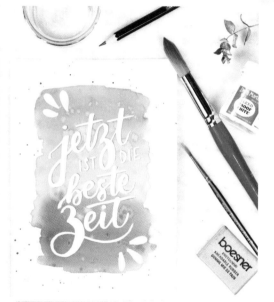

jetzt ist die beste Zeit

There's no time like the present

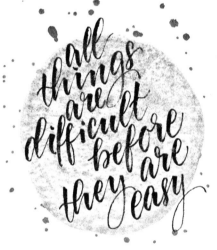

all things are difficult before they are easy

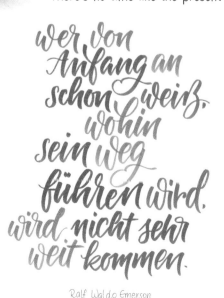

wer von Anfang an schon weiß, wohin sein Weg führen wird, wird nicht sehr weit kommen.

Ralf Waldo Emerson

if you know from the outset where you
are going, you will not get very far

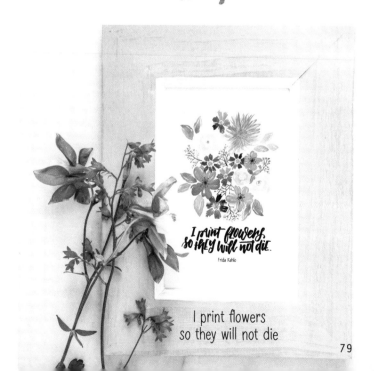

I print flowers, so they will not die.
Frida Kahlo

I print flowers
so they will not die

TIPS FOR YOUR BRUSH LETTERING JOURNEY

1) **Familiarise yourself with the essentials** and practise the basic strokes. You can certainly copy other people's lettering for practice purposes. This is allowed provided that you do not post it anywhere online or present it as your own work. The best idea is to collect these practice exercises in a drawer or a file just for your own use. And if you want to show them to anyone, don't forget to point out who the original author is!!!

2) **Try out different tools and materials.** Then you are sure to find your favourite pen or brush very quickly, whilst additionally getting to know and love many others.

3) **Take a deliberate look at scripts.** We are surrounded by scripts, whether in day-to-day advertising, on house facades, when out shopping or even on the computer. If you like a script or a certain style, then analyse it, copy it (see point 1!) and then create your own script from it.

4) **Practise, practise, practise ...** as much as possible. Repeat the basic strokes and the letters until you no longer need to think about how you produce them, because, in time, your muscles and your memory will save the sequence of movements.

5) **For your first attempts at lettering use lower case letters.** In the beginning, they are easier to draw than upper case letters. Apart from that, you can also immediately produce connected letters (words) with them.

6) **Write the letters and words in a way that feels natural to you.** Do not try to copy anyone or any style completely. Create your own style, thereby making it authentic!

7) **Be creative and uninhibited!** Mix different letters, upper and lower case writing, combine cursive script with print script, thick and thin strokes – as per the motto: "MIX AND MATCH" (see page 36).

8) **Don't compare your work to that of others,** but at most to your performance from the previous day/week/month/year. You will see how quickly your lettering skills change and improve.

9) **Be inquisitive** and keep your eyes and ears open for new trends and new material. And believe me, there is soooooo much to discover!

10) and this is the most important thing of all:
Have fun!!!